BEWARE,
for I am
FEARLESS

and therefore
POWERFUL.

FRANKENSTEIN BY MARY SHELLEY

Mary Shelley

Born: London, England, 1797.
Died: London, England, 1851.

Frankenstein was published in 1818. Set towards the end of the 1700s, it tells the fantastic story of scientist Victor Frankenstein, and how he brought an assemblage of human corpses back to life, creating Frankenstein's monster. Frankenstein is unable to escape his monstrous creation, responsible for a number of deaths. When Frankenstein dies, the monster expresses remorse for everything he has done, and he too is ready to die.

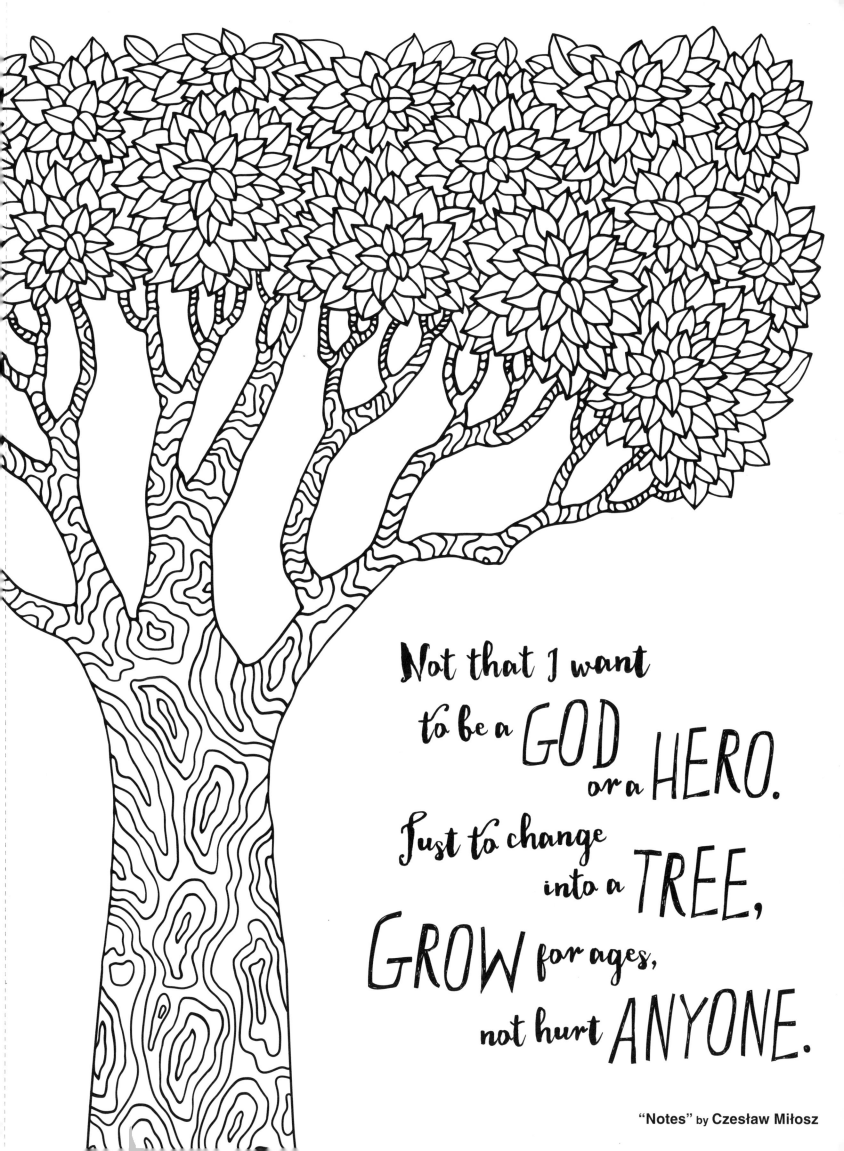

Not that I want
to be a GOD or a HERO.
Just to change into a TREE,
GROW for ages,
not hurt ANYONE.

"Notes" by Czesław Miłosz

Czesław Miłosz

Born: Šeteniai, Lithuania, 1911.
Died: Kraków, Poland, 2004.

These quoted lines are the most
repeated of Miłosz's philosophical
expressions. Miłosz was a poet, writer,
translator and diplomat, and his place
among the greatest writers of the 20th
century was confirmed when he won
the Nobel Prize for Literature in 1980.
Many of his poems deal with loss and
destruction and society's lack of
moral fortitude.

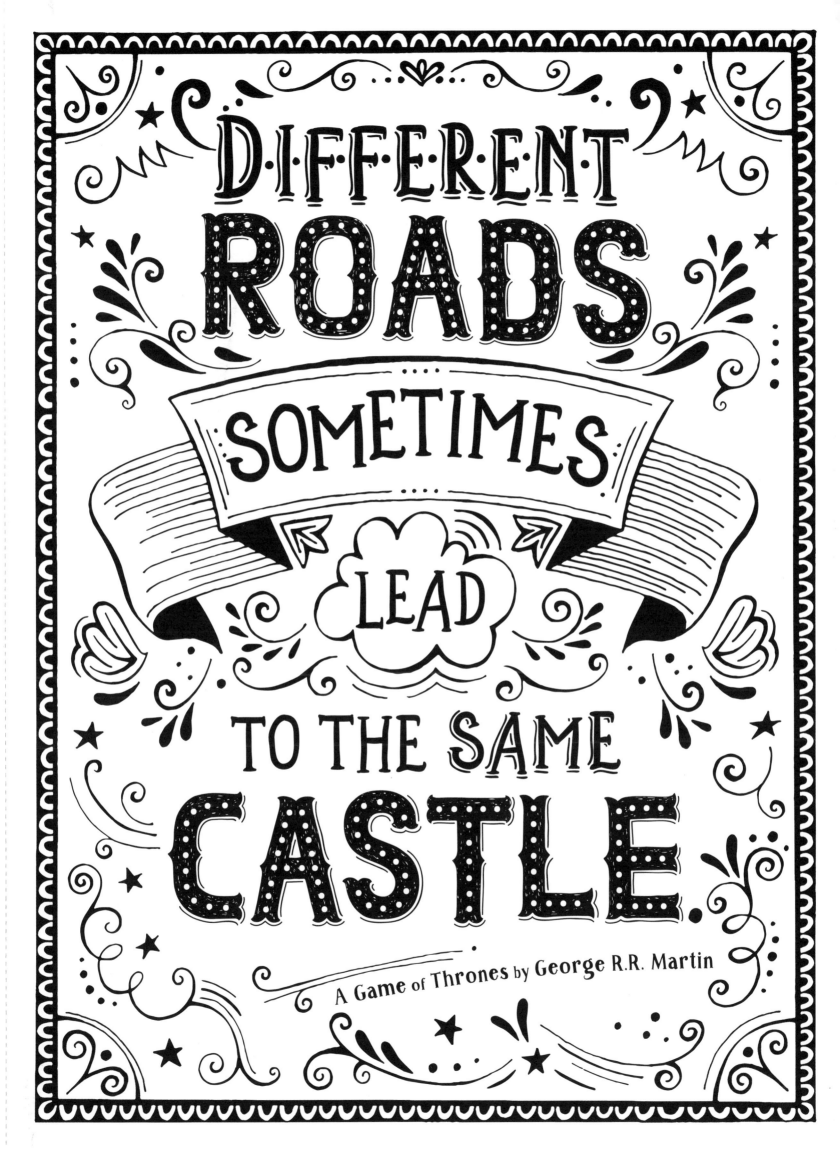

DIFFERENT ROADS SOMETIMES LEAD TO THE SAME CASTLE.

A Game of Thrones by George R.R. Martin

George R.R. Martin

Born: Bayonne, NJ, 1948.

A Game of Thrones, first published 1996, is the first novel in Martin's fantasy and strategy saga, *A Song of Ice and Fire*. In this novel, which covers a year in Westeros, characters have to choose between love and family or loyalty to the realm, honor and duty. The choices and consequences are never clear-cut. Though critically acclaimed on first publication, *A Game of Thrones* reached its widest audience when it became a TV series in 2011.

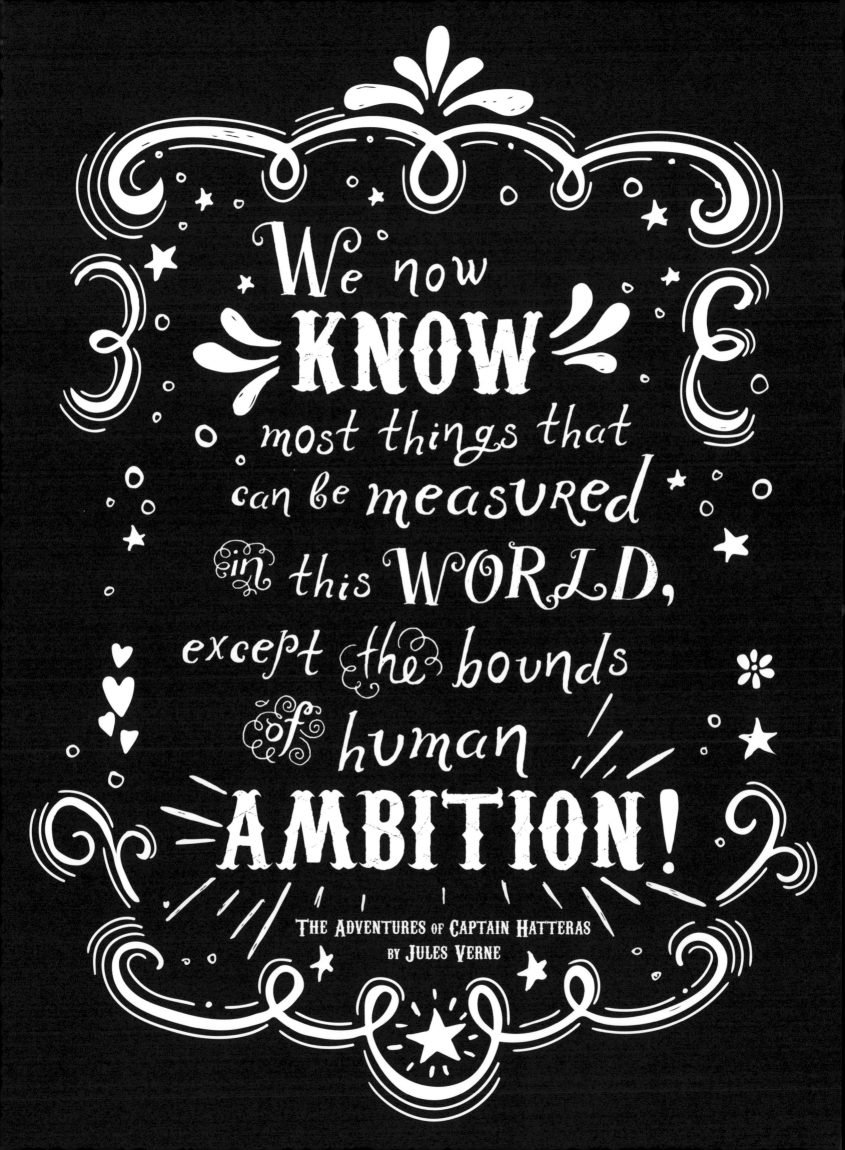

We now **KNOW** most things that can be measured in this WORLD, except the bounds of human **AMBITION!**

THE ADVENTURES OF CAPTAIN HATTERAS
BY JULES VERNE

Jules Verne

Born: Nantes, France, 1828.
Died: Amiens, France, 1905.

The Adventures of Captain Hatteras
is a two-part adventure novel, first
published in 1864. The Captain Hatteras
character may have been based on
John Franklin, a British naval officer
and Arctic explorer. The novel describes
Hatteras's fraught expedition to the
North Pole. He and some of the crew
survive a mutiny, the destruction of
the ship and a winter on the ice.

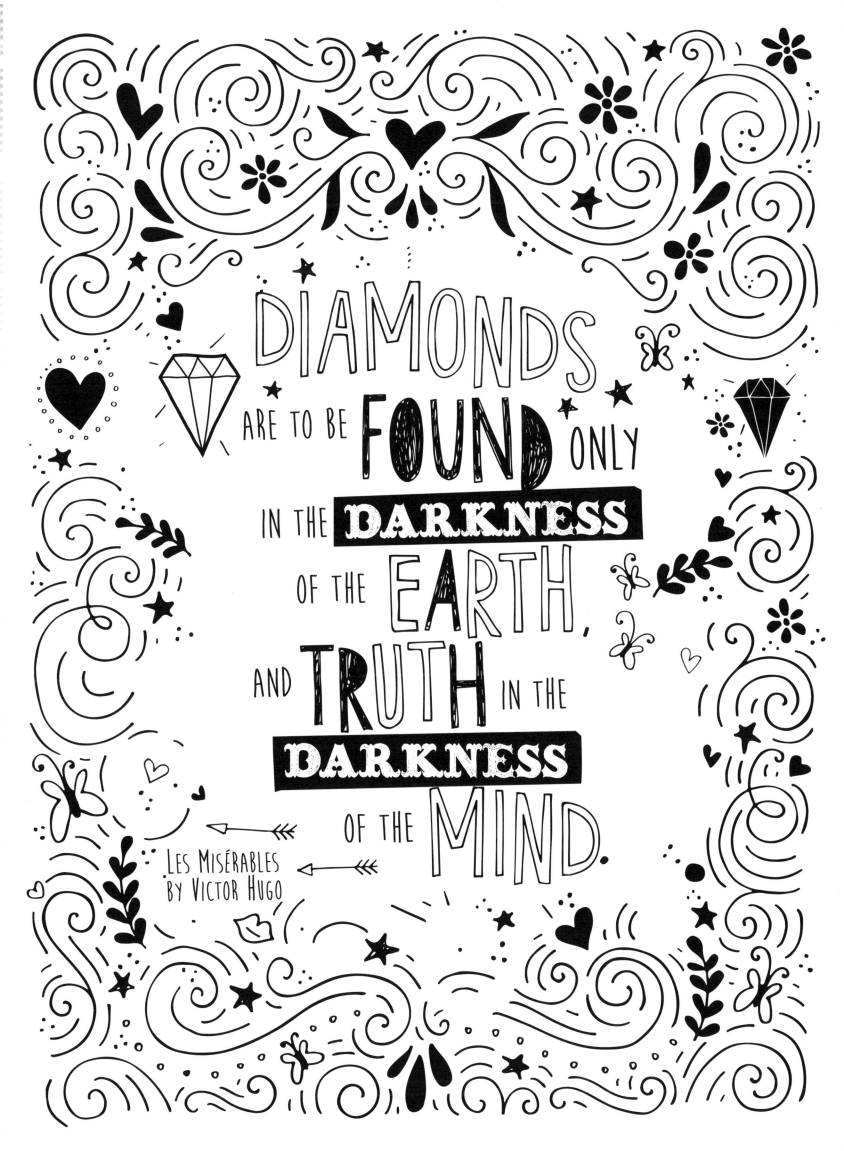

DIAMONDS ARE TO BE FOUND ONLY IN THE DARKNESS OF THE EARTH, AND TRUTH IN THE DARKNESS OF THE MIND.

Les Misérables by Victor Hugo

Victor Hugo

Born: Besançon, France, 1802.

Died: Paris, France, 1885.

Les Misérables, first published in 1862, follows ex-convict Jean Valjean, Fantine and many other characters from 1815 through to the June Rebellion in Paris in 1832. This French historical novel is regarded as Hugo's greatest work, a masterpiece that has lived on in stage adaptations and films.

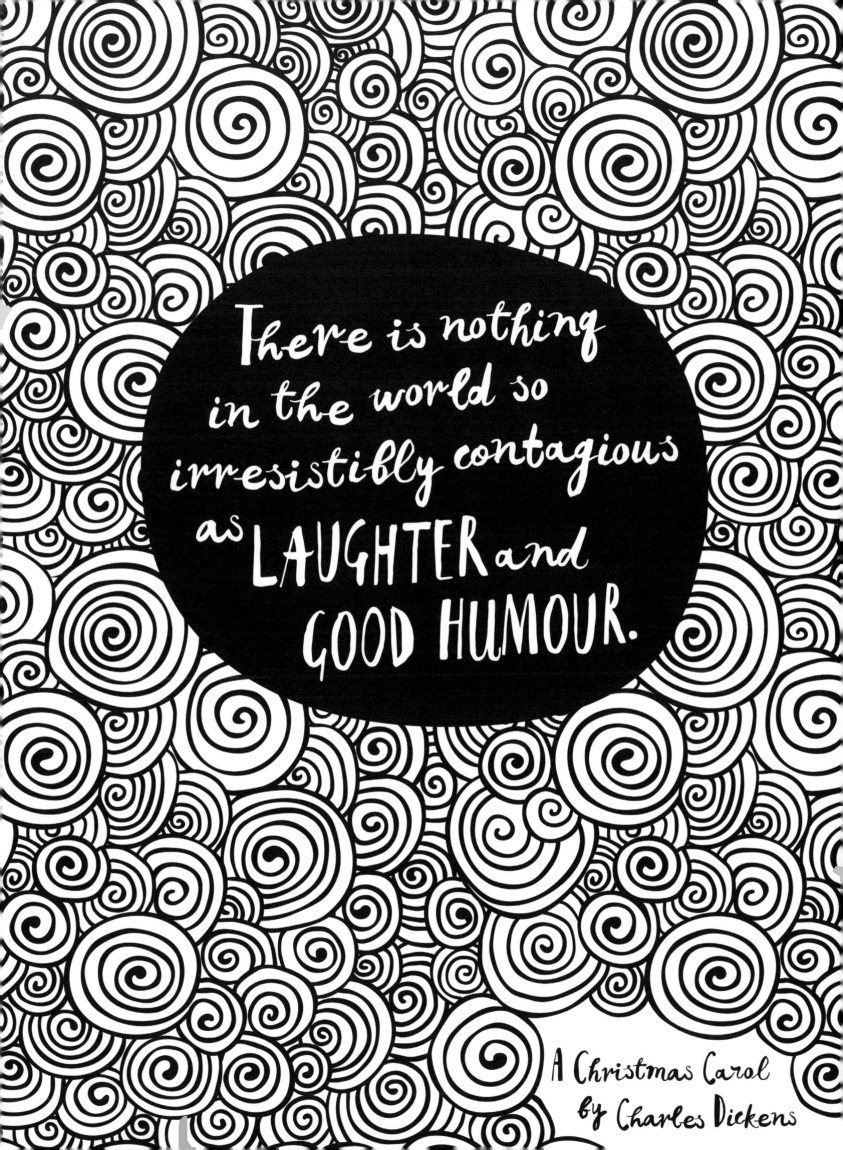

Charles Dickens

Born: Portsmouth, England, 1812.
Died: Higham, England, 1870.

A Christmas Carol was published in 1843, and was as popular then as it is today. The story follows Ebenezer Scrooge, who replies to Christmas well-wishers with, "Bah! Humbug!" on his redemptive journey from mean and miserly to kind and generous. Other famous characters in this novella are Scrooge's clerk Bob Cratchit and his son Tiny Tim, and Jacob Marley, the ghost of Scrooge's dead partner.

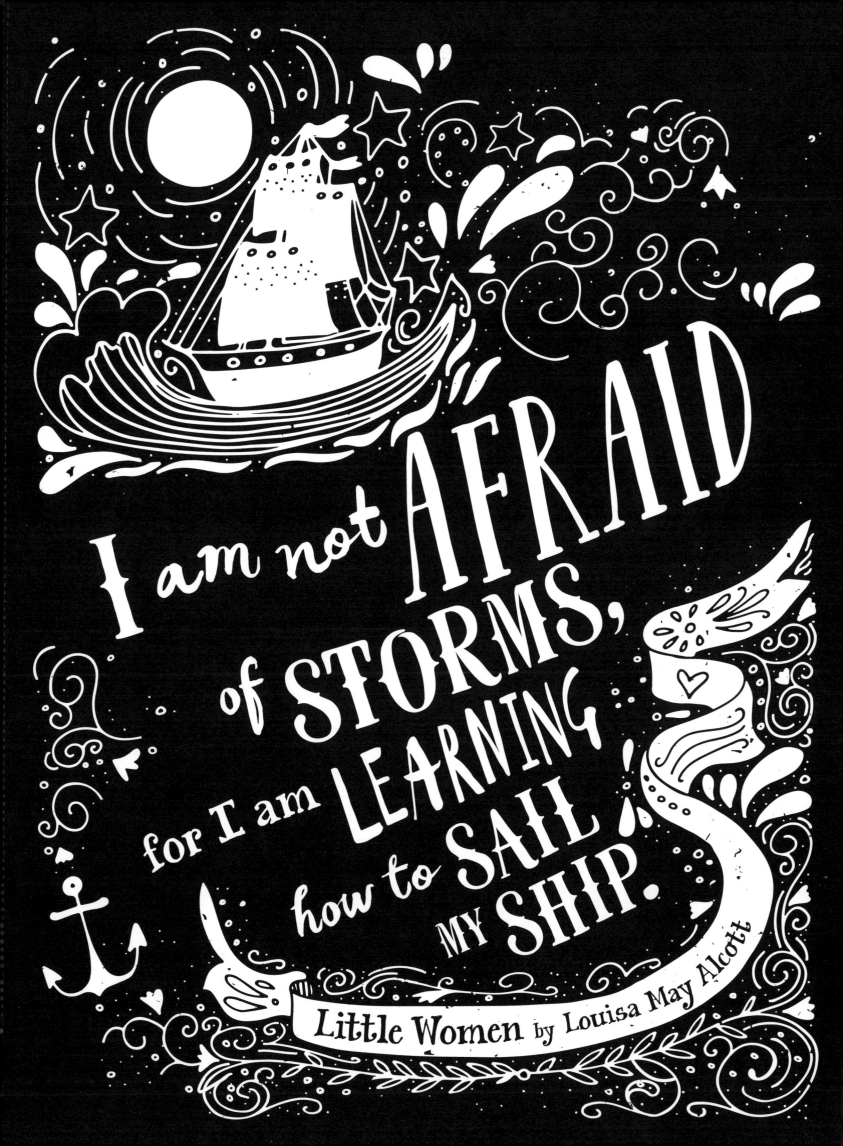

I am not AFRAID of STORMS, for I am LEARNING how to SAIL MY SHIP.

Little Women by Louisa May Alcott

Louisa May Alcott

Born: Germantown, PA, 1832.
Died: Boston, MA, 1888.

Little Women, published in two volumes in
1868 and 1869, is a coming-of-age drama
featuring sisters Jo, Meg, Beth and Amy
March, and their mother, Marmee, during the
time of the Civil War. This close, loving and
religious family stand together in good times
and bad – facing poverty, hunger and certain
tragedy. As the sisters surmount each
hardship, the novel concludes with most of
the family gathered together, expressing
gratitude and hopeful for a happy future.

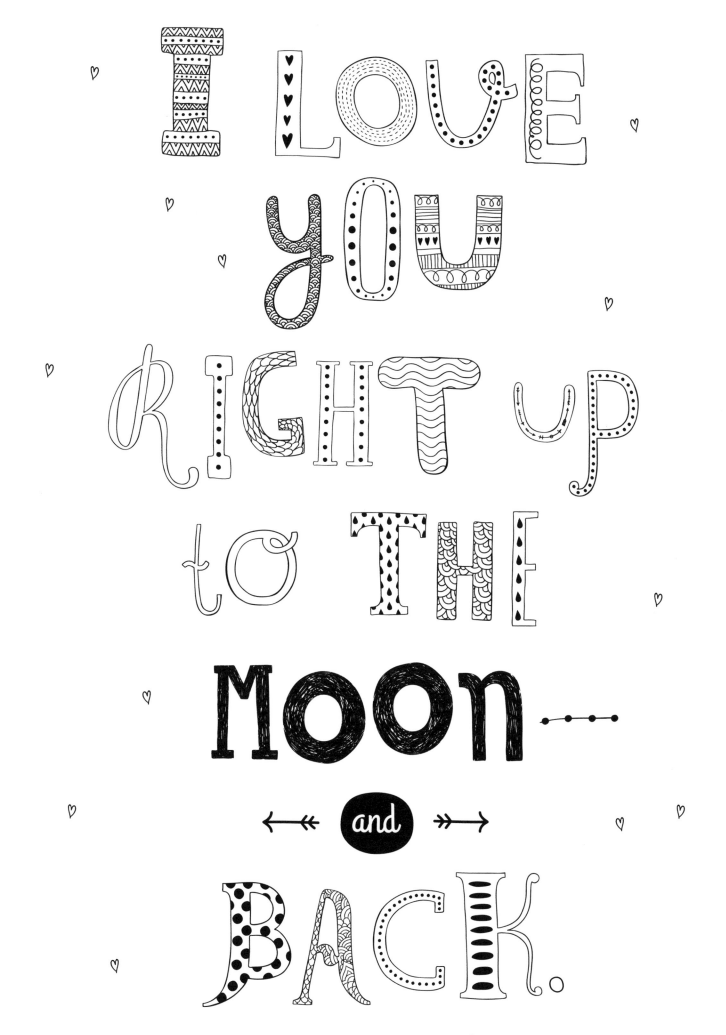

GUESS HOW MUCH I LOVE YOU by Sam McBratney

Sam McBratney

Born: Belfast, Northern Ireland, 1943.

Guess How Much I Love You is perhaps the best known and most loved of McBratney's many picture books for children. Published in 1994 and illustrated by Anita Jeram, it shows Little Nutbrown Hare and Big Nutbrown Hare using ever-larger ways to express how much they love each other. The book has been translated into fifty-three languages and has sold millions of copies.

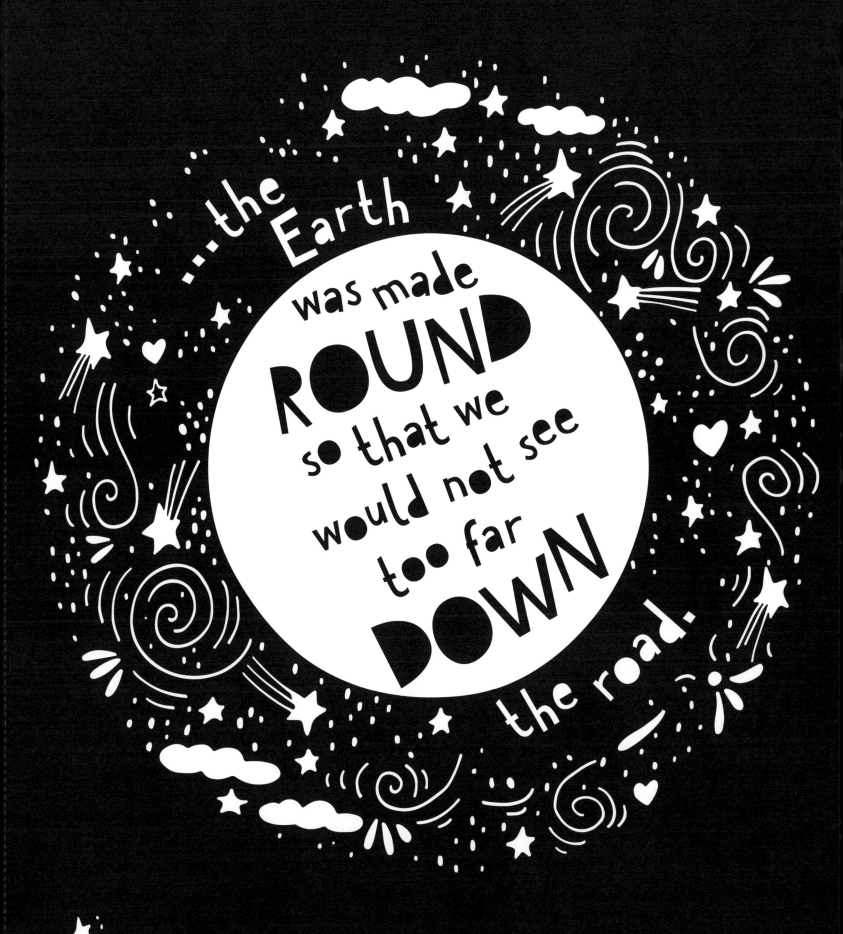

...the Earth was made ROUND so that we would not see too far DOWN the road.

Out of Africa by Isak Dinesan (Karen Blixen)

Karen Blixen

Born: Rungsted, Denmark, 1885.
Died: Rungsted, Denmark, 1962.

Published in 1937, *Out of Africa* is a record
of Blixen's years in Kenya. After her divorce
from her husband, Blixen ran their coffee
plantation alone, until severe drought forced
her return to Denmark. The book tells of her
love for Africa, its people and their way of
life. The film version of the book (1985)
starred Meryl Streep as Blixen and Robert
Redford as Denys Finch Hatton, a big
game hunter and Blixen's companion.

Think of all the beauty still left around you and be happy.

The Diary of a Young Girl
by Anne Frank

Anne Frank

Born: Frankfurt, Germany, 1929.
Died: Bergen-Belsen Concentration Camp,
 Germany, 1945.

The Diary of a Young Girl, published
after its author died of typhus in a Nazi
concentration camp, is the record of the
two years Anne and her family spent in
hiding in a secret room above a factory
in Amsterdam, Netherlands. In the diary,
Anne wrote her deepest thoughts and
feelings. It is an honest, heartbreaking
glimpse into a horrific time.

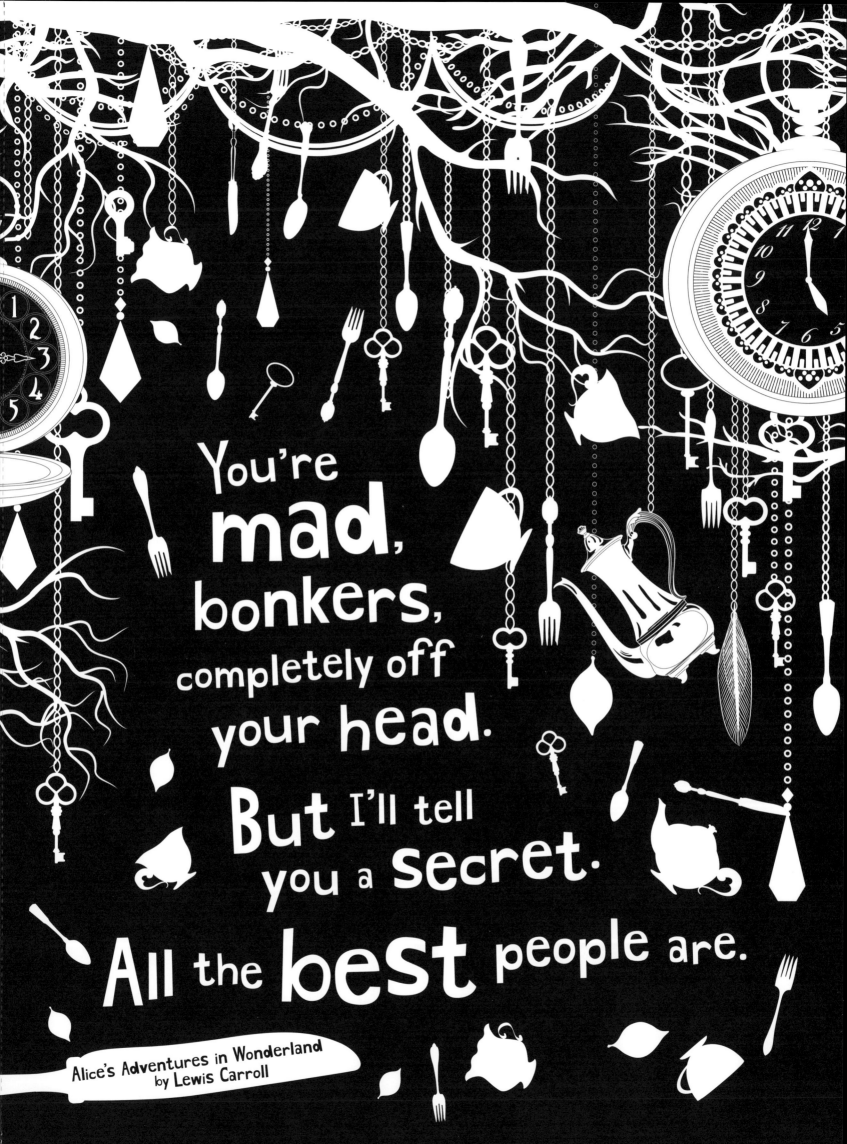

You're mad, bonkers, completely off your head. But I'll tell you a secret. All the best people are.

Alice's Adventures in Wonderland by Lewis Carroll

Lewis Carroll

Born: Daresbury, England, 1832.
Died: Guildford, England, 1898.

Alice's Adventures in Wonderland, published
in 1865, tells a delightfully fantastical tale of
escaping down rabbit holes, changing
size, magical concoctions, tea parties,
and strange characters including the
Hatter, the March Hare, the Dormouse,
the Cheshire Cat and the King and Queen
and Knave of Hearts. But when the fantasy
becomes uncomfortable, Alice wakes up
and realizes it was all a dream.

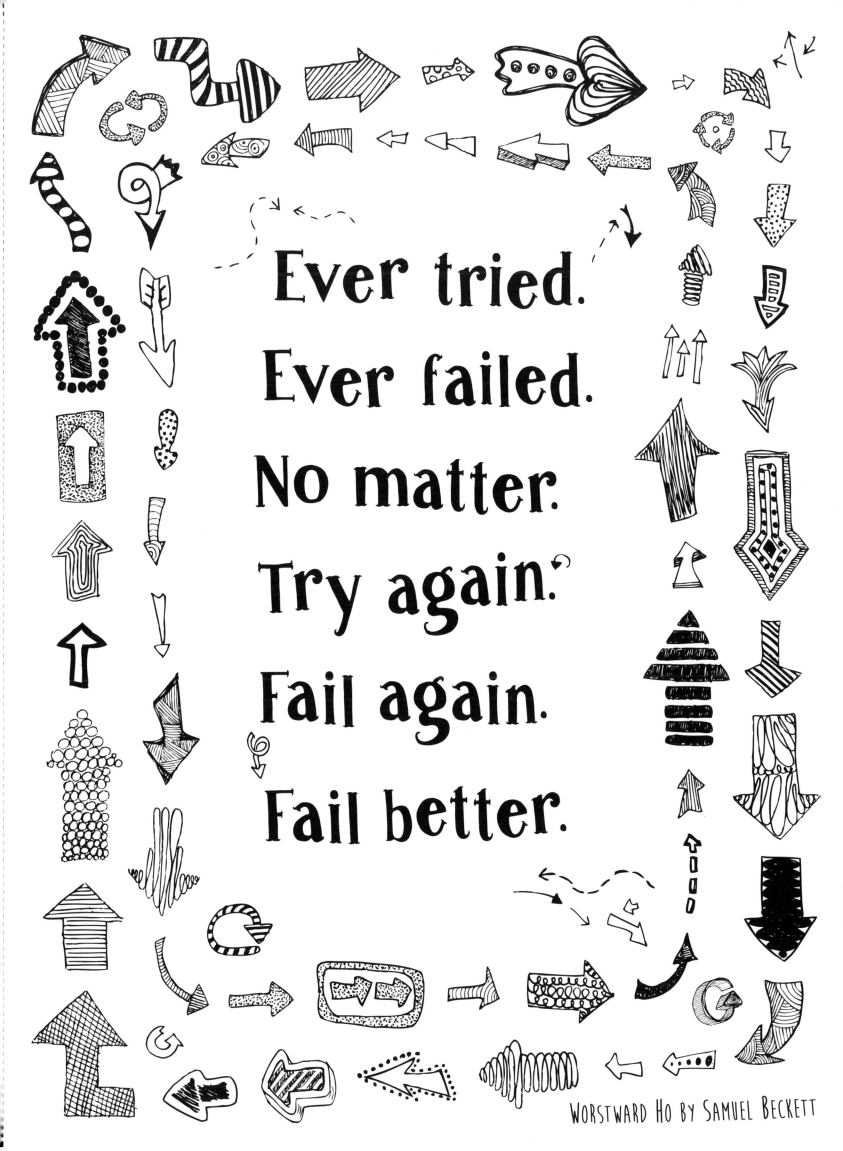

Ever tried.
Ever failed.
No matter.
Try again.
Fail again.
Fail better.

Worstward Ho by Samuel Beckett

Samuel Beckett

Born: Foxrock, Ireland, 1906.

Died: Paris, France, 1989.

The title of *Worstward Ho*, a prose piece
written by Samuel Beckett in 1983, has
been called a parody of *Westward Ho!*, a
historical novel by Charles Kingsley about
Francis Drake, the Caribbean and battles
with the Spanish. While the novel is
full-blown and epic, Beckett's work is
pared to the minimum – short words,
short sentences, sparse descriptions – in
which the author contemplates existence.

You are BRAVER than you BELIEVE, STRONGER than you SEEM, AND SMARTER than you THINK.

Winnie-The-Pooh by A.A. Milne

A.A. Milne

Born: London, England, 1882.
Died: Hartfield, England, 1956.

Winnie-the-Pooh, illustrated by Ernest H. Shepard and published in 1926, is Milne's first book of stories about Christopher Robin, his stuffed bear Winnie-the-Pooh and friends Eeyore, Piglet, Tigger, Kanga and Roo. Their adventures and exploits in the Hundred Acre Wood have amused and delighted generations of children and their parents all over the world.

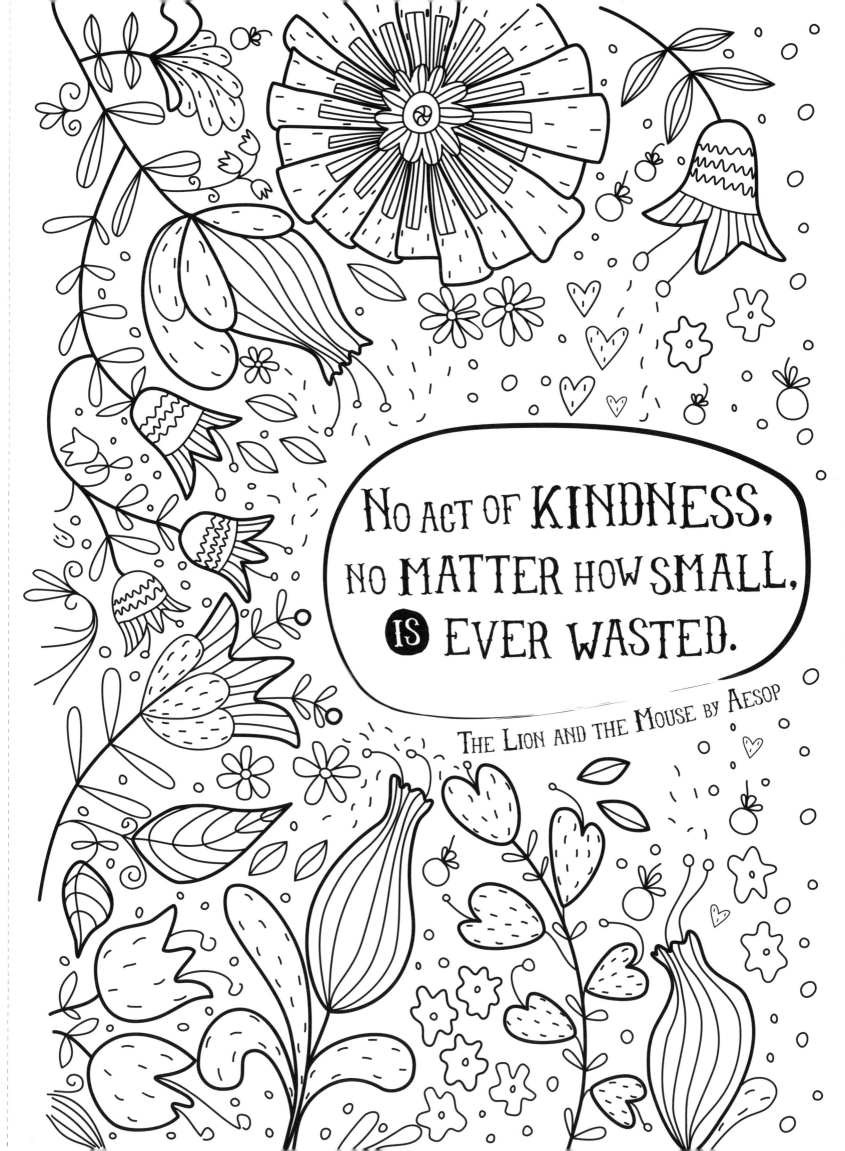

No act of KINDNESS, no MATTER how SMALL, IS EVER WASTED.

THE LION AND THE MOUSE BY AESOP

Aesop

Born: Ancient Greece, 620 BCE.
Died: Ancient Greece, 564 BCE.

The Lion and the Mouse is just one of
Aesop's hundreds of fables. A fable is a
story, usually with animal characters, that
conveys a moral message. The moral of
The Lion and the Mouse is that any act of
kindness is worthwhile; friends come in all
shapes and sizes and no creature is too
small to help another. It is thought Aesop
was a slave, but despite humble origins
his stories have spread throughout the
world, in many languages, and in many
forms, including musicals, films, books,
TV and even opera.

Don't let them get you down. Be cheeky and wild and wonderful.

Pippi Longstocking
by Astrid Lindgren

Astrid Lindgren

Born: Vimmerby, Sweden, 1907.

Died: Stockholm, Sweden, 2002.

First published in Sweden in 1945, *Pippi Longstocking* is the first in a series of books that feature Pippi, a confident, offbeat and superstrong nine-year-old girl. Pippi scorns conventional adult attitudes, and though she never wants to grow up, she also doesn't want to be treated like a child. Pippi's adventures with her horse, her monkey and her best friends Tommy and Annika have made Lindgren one of the most beloved children's authors of our time. Created in her memory, the Astrid Lindgren Memorial Award is the world's largest monetary award for children's and youth literature.

All GROWN-UPS were once CHILDREN... but only few of them REMEMBER it.

The Little Prince
by Antoine de Saint-Exupéry

Antoine de Saint-Exupéry

Born: Lyon, France, 1900.
Died: Marseille, France, 1944.

The Little Prince, first published in 1943, tells the story of a meeting between a crashed aviator (Saint-Exupéry was a military pilot) and the Little Prince from asteroid B-612. Philosophical and mystical in its explorations of human nature, *The Little Prince*, a children's book for both adults and children, is treasured by readers of all ages, and filled with fantasy, logic and love. It is the fourth-most translated book in the world and is one of the best-selling books ever published.

The past is a FOREIGN COUNTRY: they do things DIFFERENTLY there.

The Go-Between
by L.P. Hartley

L.P. Hartley

Born: Whittlesey, England, 1895.

Died: London, England, 1972.

The Go-Between, published in 1953, opens
with elderly Leo Colston reminiscing over his
diary from the summer of 1900 when he was
thirteen years old. Colston had spent that
summer at a school friend's grand home,
Brandham Hall, and had been used as a
go-between by his friend's sister, Marian;
an unwanted suitor, Lord Trimingham; and
Marian's love, Ted the farmer.

Nothing in the world is ever completely wrong...

Even a stopped clock is right twice a day.

Brida by Paulo Coelho

Paulo Coelho

Born: Rio de Janeiro, Brazil, 1947.

Brida, published in 1990, is the story of an Irish girl's search for knowledge in which the arts of witchcraft and magic merge with modern life. Brida, the main character, already has an interest in Wicca when she meets a hermit and a witch, but they give her the confidence to dance to the music of the world. Coelho's story is touched with magic but is ultimately about universal emotions.

Do a **LOONY-GOONY** DANCE
'CROSS THE KITCHEN FLOOR,
PUT SOMETHING **SILLY** IN THE WORLD
THAT AIN'T BEEN THERE BEFORE.

"Put Something In" by Shel Silverstein

Shel Silverstein

Born: Chicago, IL, 1930.

Died: Key West, FL, 1999.

"Put Something In" appears in Silverstein's *A Light in the Attic* (1981). Silverstein was a poet, author, musician, singer-songwriter, cartoonist and illustrator. "Put Something In," and the rest of the poems in *A Light in the Attic*, are meant for both children and adults, reminding us of the importance of random acts of silliness, fun and creativity.

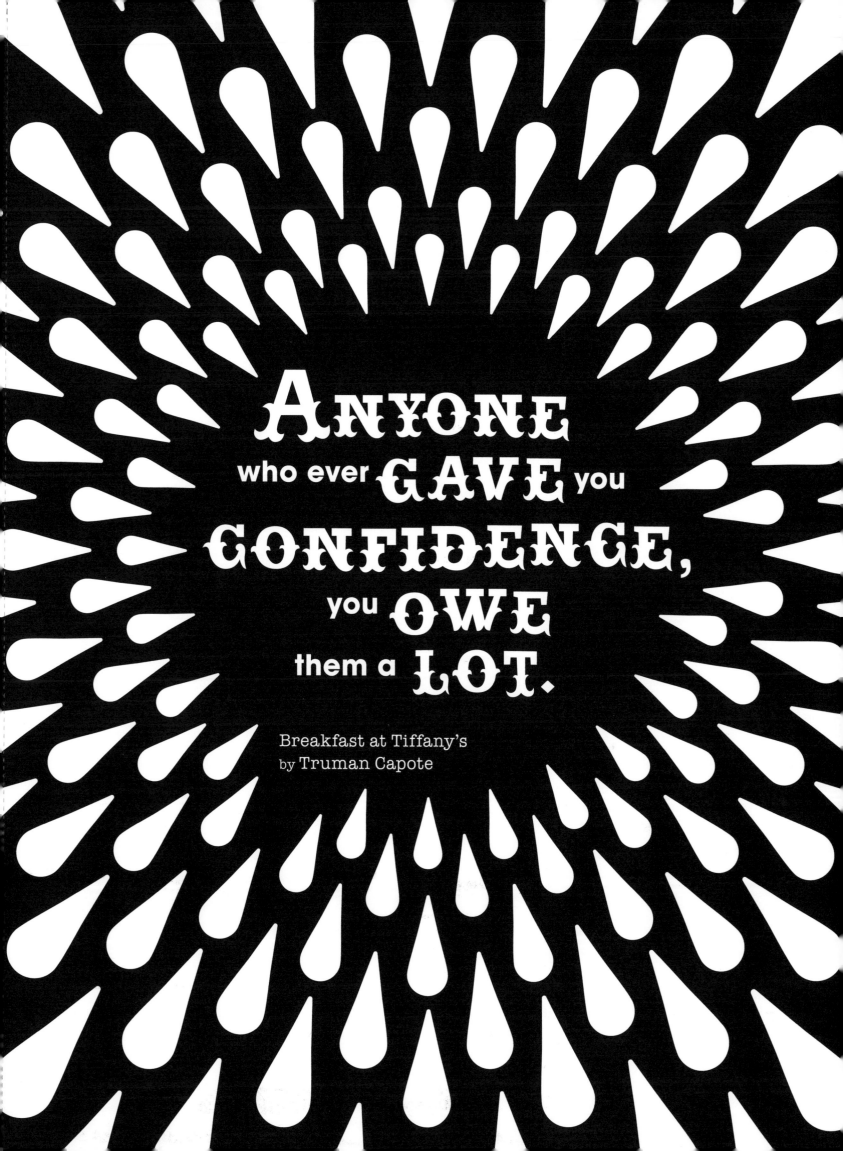

ANYONE who ever GAVE you CONFIDENCE, you OWE them a LOT.

Breakfast at Tiffany's
by Truman Capote

Truman Capote

Born: New Orleans, LA, 1924.
Died: Los Angeles, CA, 1984.

Capote published *Breakfast at Tiffany's* in 1958, and it remains one of his best-known works, in part because of the 1961 iconic film of the same name starring Audrey Hepburn as Holly Golightly. The novella follows the outspoken Holly as she develops a friendship with her neighbor, the book's narrator. The narrator eventually comes to see that behind Holly's bravado is a fragile, sensitive young woman with whom he falls in love.

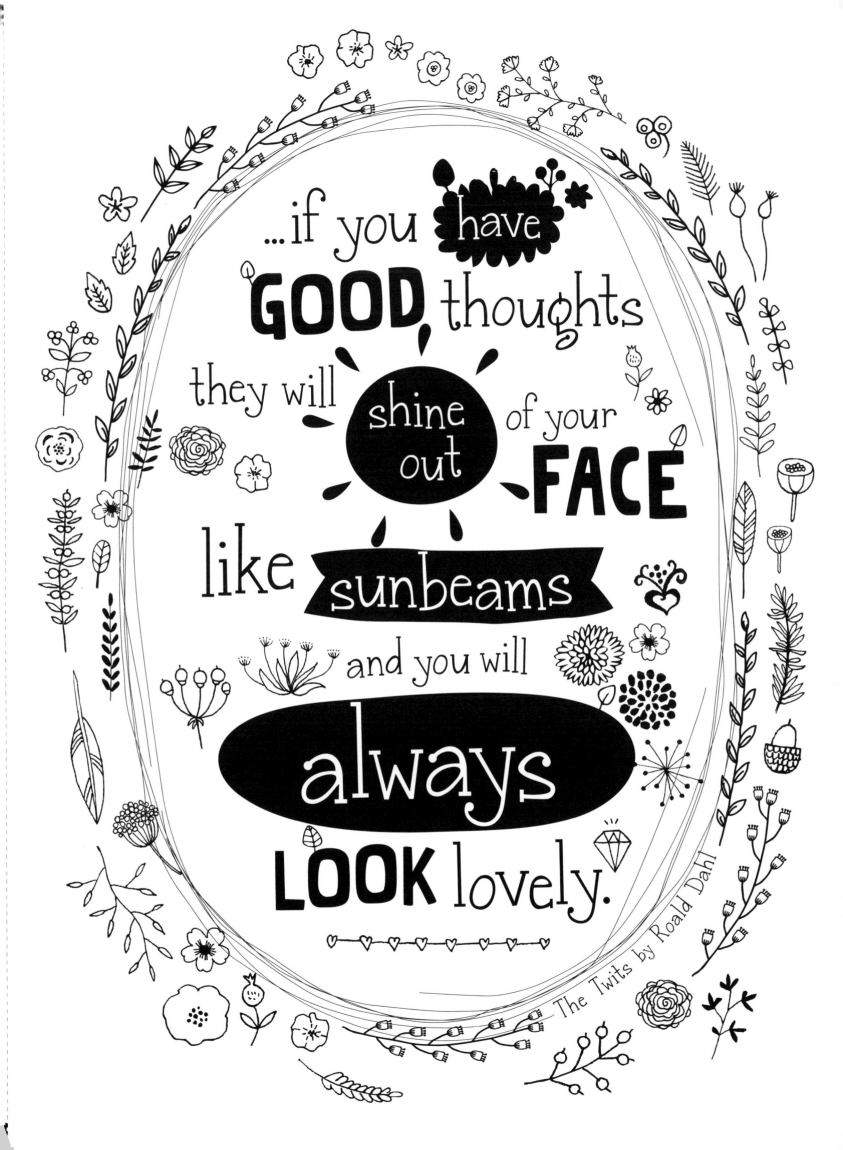

...if you have **GOOD** thoughts they will shine out of your **FACE** like sunbeams and you will **always LOOK** lovely.

The Twits by Roald Dahl

Roald Dahl

Born: Cardiff, Wales, 1916.
Died: Oxford, England, 1990.

The Twits, published in 1980 and illustrated by Quentin Blake, tells the story of Mr. and Mrs. Twit and the wicked tricks they play on each other (including Mrs. Twit putting her glass eye in Mr. Twit's beer!). The couple are also cruel to their "pet" monkeys and birds, which finally get revenge on the Twits by turning everything – including the Twits – upside down. It's a classic Dahl tale, full of mischief, mayhem and humor.

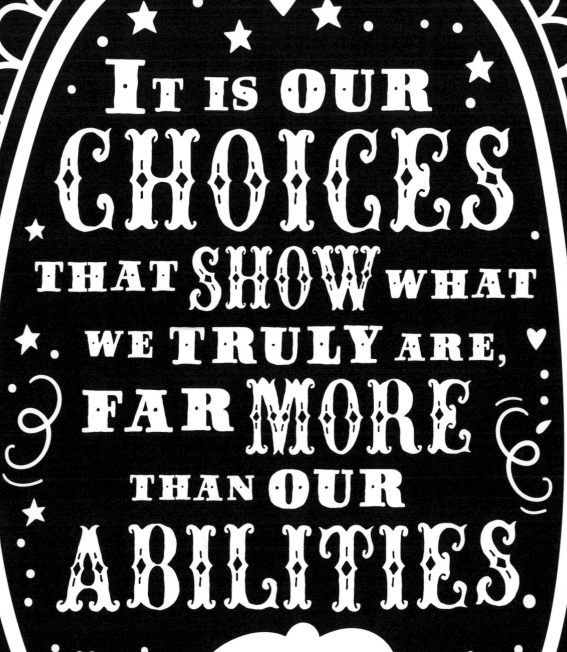

It is OUR CHOICES THAT SHOW WHAT WE TRULY ARE, FAR MORE THAN OUR ABILITIES.

HARRY POTTER
and the
CHAMBER of SECRETS
by J.K. ROWLING

J.K. Rowling

Born: Yate, England, 1965.

Harry Potter and the Chamber of Secrets, published in the US in 1999, is the second of the seven *Harry Potter* books. (It was released as a film in 2002.) The book starts with Harry receiving a warning: if he returns to Hogwarts School of Witchcraft and Wizardry for his second year, disaster awaits. The series continues in its exploration of adolescence, friendship, loss, loyalties and the ongoing pursuit of self-identity.

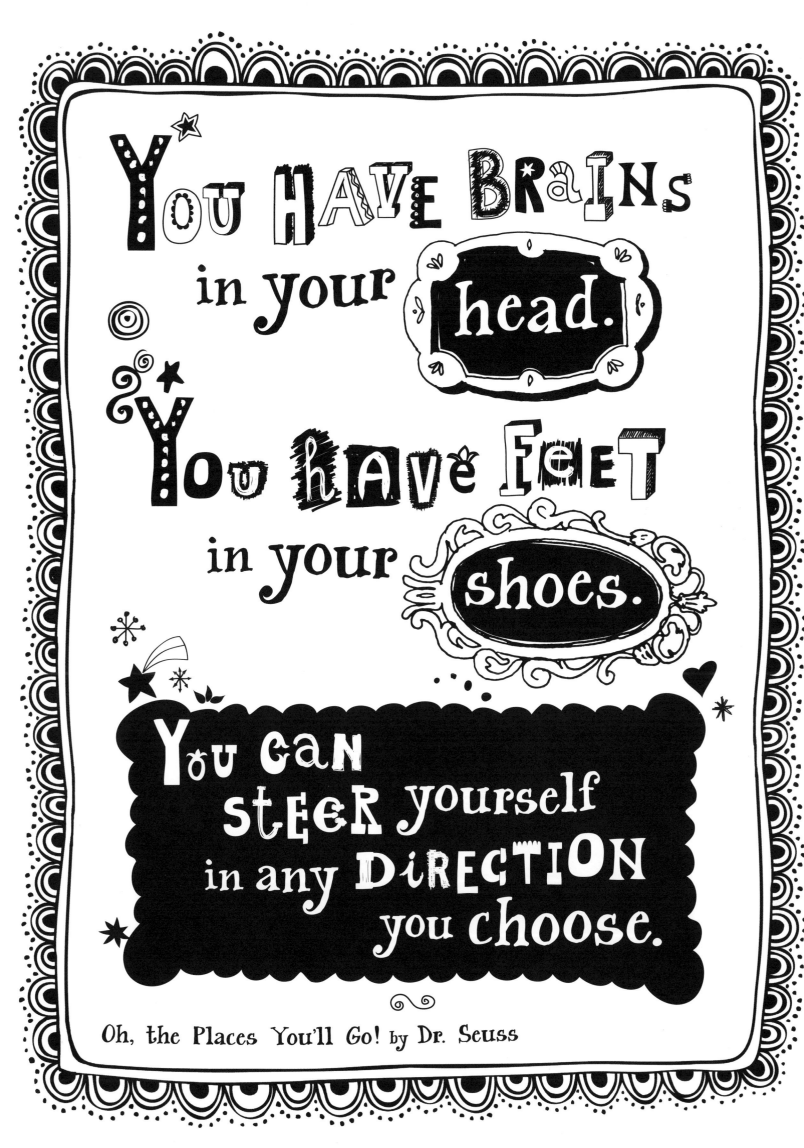

You HAVE BRAINs in your **head.**

You HAVE FEET in your **shoes.**

You CAN steeR yourself in any DiRECTION you choose.

Oh, the Places You'll Go! by Dr. Seuss

Dr. Seuss (Theodor Seuss Geisel)

Born: Springfield, MA, 1904.

Died: La Jolla, CA, 1991.

Oh, the Places You'll Go!, published in 1990, is Dr. Seuss' last published book before his death. This story about life's challenges has particular resonance with readers anticipating life's milestones. In the book, the protagonist (representing the reader) travels through colorful geometric landscapes and arrives at "The Waiting Place" where all wait for something to happen. The protagonist continues on, now excited for things to come.